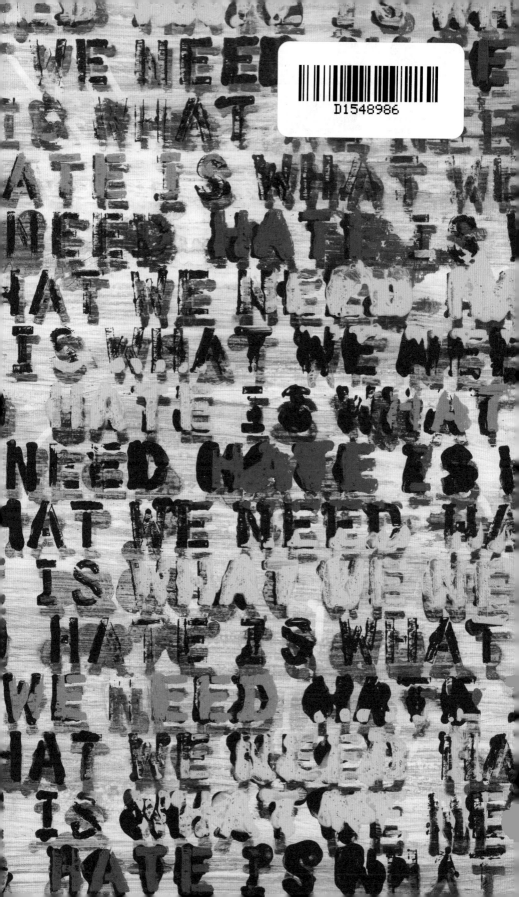

HATE IS WHAT WE NEED

By Ward Schumaker

CHRONICLE BOOKS

SAN FRANCISCO

"In politics stupidity is not a handicap."
—Napoleon Bonaparte

HATE WHAT IS WHAT WE NEED

HATE IS WHAT WE NEED

THIS IS THE LARGEST AUDIEN

HE POWERS OF THE PRESIDENT

PER TO WITNESS AN INAUGURATIO

WILL NOT BE QUESTIONED

I WENT TO AN
IVY LEAGUE SCHOOL
I AM VERY
HIGHLY EDUCATED

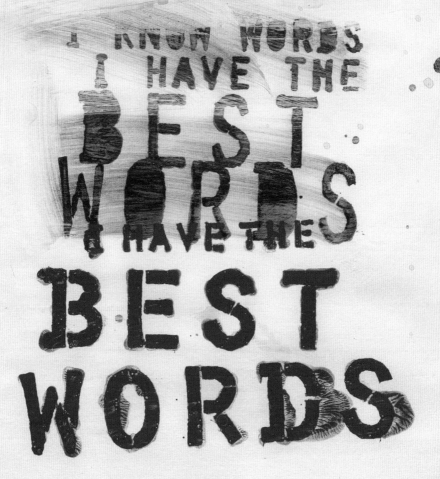

I KNOW WORDS
I KNOW WORDS
I HAVE THE
BEST
WORDS
I HAVE THE
BEST
WORDS

MY FINGE
LON G AND
IT HAS BEEN
YARD
OTHE
PART
OF MY

R SARE

BEAUTIFUL AS,

ELL-DOCUMENTED, ARE

OUS

BODY

MY IQ IS ONE O

AND YOU

PLEASE DON'T

OR INS

IT'S NOT Y

I.Q.

MY IQ IS
ONE OF THE BIGGEST
F THE BIGGEST
KNOW IT!
FEEL STUPID
ECURE.
OUR FAULT.
ON'T FEEL STUPID
IT'S NOT YOUR FAULT

HOW S
ARE
THE P
OF

TUPID

EOPLE

IOWA?

EVERYTHI

VIRT

EVERYTHIN

VIRT

HAS BEEN

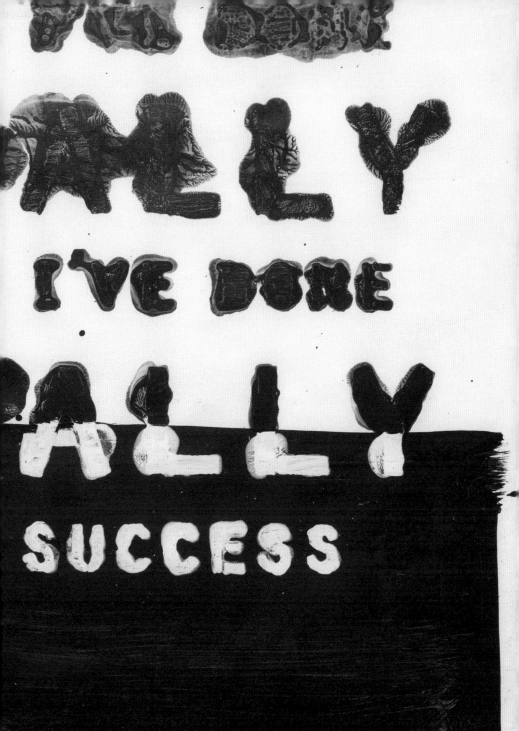

I GET A LOT OF CREDIT FOR COMB-OVERS. BUT IT'S NOT REALLY A COMB-OVER IT'S SORT OF A LITTLE BIT FORWARD AND BACK. I'VE COMBED IT THE SAME FOR YEARS. SAME THING, EVERY TIME.

DO I LOOK
LIKE A
PRESIDENT?
HOW
HANDSOME
AM I, RIGHT?
HOW
HANDSOME?

SHOOT

I COULD STAND

IN THE MIDDLE

OF 5TH AVENUE

AND SHOOT SOMEBODY

AND I WOULDN'T

LOSE VOTERS.

CANCEL

SOMEBODY

I'M JUST THINKING
TO MYSELF RIGHT NOW,
WE SHOULD JUST
CANCEL THE ELECTION
AND JUST GIVE IT
TO TRUMP, RIGHT?

ELECTION

FA
NE

DON'T BE SO OVERLY DRAMATIC ABOUT IT

YOU'RE SAYING IT'S A FALSEHOOD

KE
E
WS

SEAN SPICER GAVE ALTERNATE FACTS

WE HAVE
DONE
THAN PERHAPS
ANY OTHER
IN THE

THINK

MORE
PRESIDENT
FIRST
100 DAYS

THE CONCEPT OF GLOBAL WARMING WAS CREATED BY AND FOR THE CHINESE

GLOBAL WARMING

IN ORDER

TO MAKE

THE U.S.

MANUFACTURING

NON-COMPETITIVE

THE CHINESE

WOMEN
TREAT THEM
LIKE
WOMEN;
YOU
HAVE
TO TREAT
THEM
LIKE
SHIT
SHIT

I'M NOT STEVE BANNON. I'M NO

WHEN YOU'
THEY LET
YOU CAN DO
GRAB THE
PUS
YOU CAN D

RYING TO SUCK MY OWN COCK.

BE A STAR
YOU DO IT
ANYTHING
M BY THE
SY
ANYTHING

YOU KNOW
IT REALLY
DOES'NT MATTER
WHAT
THE MEDIA WRITE
AS LONG AS
YOU'VE GOT
A YOUNG
AND BEAUTIFUL
PIECE OF ASS

PIECE OF ASS

I THINK THAT PUTTING A NIP

DOESNT MATTER

IF
WILLARY CLINTON
CAN'T SATISFY
HER HUSBAND
WHAT MAKES HER
THINK THAT
SHE CAN SATISFY
AMERICA?

WORK IS A VERY DANGEROUS THING

LOCK HER UP!

LOOK
AT
THAT
FACE!
CAN YOU
IMAGINE
THAT,
THE FACE
OF THE
NEXT
PRESIDENT?

WOULD ANYONE

YOU COULD SEE
THERE WAS BLOOD
COMING OUT
OF HER EYES
BLOOD COMING
OUT OF HER
WHATEVER

VOTE FOR THAT?

BECAUSE
I AM SO
GOOD-LOOKING

IT'S VERY HARD
FOR THEM
TO ATTACK ME
ON LOOKS
BECAUSE
I AM SO
GOOD-LOOKING

IT'S VERY HARD
FOR THEM
TO ATTACK ME
ON LOOKS

IF YOU
SEE SOMEBODY
GETTING READY
TO THROW
A TOMATO,
KNOCK
THE CRAP
OUT OF EM
SERIOUSLY, OK?

JUST KNOCK
THE HELL—
I PROMISE YOU.
I WILL PAY
THE LEGAL FEES.
I PROMISE.
I PROMISE.

I LOVE THE POORLY EDUCATED

WE WILL HA

WIN

IF I GET

YOU MAY GET

WIN

BELIE

VE SO MUCH

I N G

ELECTED

BORED WITH

I N G

VE ME

LOOK AT MY AFRICAN-AMERICAN HERE!

EXTREMELY CREDIBLE SOURCE

HAS CALLED MY OFFICE

AND TOLD ME THAT

FREDERICK
DOUGLASS
IS AN EXAMPLE OF
SOMEBODY WHO'S
DONE AN
AMAZING JOB
AND IS GETTING
RECOGNIZED
MORE AND MORE,
I NOTICE.

I
LOVE
HISPANICS

THAT
COULD BE A
MEXICAN
PLANE
UP THERE
THEY'RE
GETTING
READY
TO ATTACK

MEXICO
WILL
PAY
FOR
THE
WALL

I HAVE TO HAVE MEXICO PAY FOR THE WALL. I HAVE TO.

I HAVE BEEN TALKING ABOUT IT FOR A TWO-YEAR PERIOD.

LET'S ALL HATE THESE PEOPLE BECAUSE MAYBE HATE IS WHAT WE NEED IF WE ARE GOING TO GET SOMETHING DONE

THE PROBLEM
IT TAKES
SO LONG
IS
NOBODY
WANTS
TO HURT
EACH OTHER
ANYMORE

I WOULD BRING BACK
WATERB[OARDING]
A HELL OF A
THAN
DON'T TELL ME
TORTURE

ARDING

AND I'D BRING BACK

LOT WORSE

WATERBOARDING

IT DOESN'T WORK

WORKS

HE IS
NOT
A WAR HERO

HE IS A
WAR HERO
BECAUSE
HE WAS
CAPTURED

I
LIKE
PEOPLE
WHO
WEREN'T
CAPTURED

I
REALLY
JUST SEE
THE
BIGNESS
OF IT ALL

I

ALONE

CAN

FIX

IT

WE WILL HAVE NO CHOICE BUT TO

TO DE... N K

ALLY

TROY

RTH

REA

CREATED
SUMMER
2017

ON
MANY

WARD SCHUMAKER

AFTERWORD

I am an artist, a painter—of books. Big, messy, one-of-a-kind hand-painted books. Frequently containing stenciled lettering, sloppy calligraphy, approaching and often accomplishing incomprehensibility.

Subject of these books? Beauty, for the most part, but also snippets of spiritual texts, fragments of dreams, and apparently irrelevant and/or inscrutable instructions. Not for the reader in search of plot, betterment, or popular imagery. And nothing political. Never anything political.

But then the night of horror arrived, that night in which the world itself became less comprehensible than many of us had previously assumed (and hoped) it to be: the night the man whose name shall not be mentioned was elected president of the United States. Not with a majority (we all know Hillary won that) but an officially authorized win nevertheless—a frightening, disheartening, dangerous, and destructive win.

Since that night, my wife and I have awoken each day with the questions we share with so many: What new horror had the president committed while we slept; what vile inanity had he voiced; who had become his latest victim? How much closer was the world to nuclear holocaust?

My personal vision of Beauty had always seemed a sufficient subject for my painting. Living under this administration seems to have changed that. This book is a small effort to respond to the president's menace: a collection of hard-to-believe, highly regrettable, dangerous, mean-spirited, and ill-informed words from the orange-faced comb-over and his minions. I am certain to have missed some of your favorites, and I am certain that each week there will be more statements that deserve to be included.

All I can answer to that is: *Resist*.

All quotes by the President of the United States unless otherwise noted.

"This was the largest audience ever to witness an inauguration."
—Sean Spicer
White House briefing room; January 21, 2017

"... the powers of the president will not be questioned. ..."
—Stephen Miller
Face the Nation; February 12, 2017

"I went to an Ivy League school. I am very highly educated. I know words. I have the best words."
Hilton Head Island, South Carolina; December 30, 2015

"My fingers are long and beautiful, as it has been well documented, are various other parts of my body."
New York Post, Page Six; April 3, 2011

"My I.Q. is one of the highest, and you all know it! Please don't feel stupid or insecure, it's not your fault."
Twitter; May 8, 2013

"How stupid are the people of Iowa?"
Fort Dodge, Iowa; November 12, 2015

"Everything I've done virtually has been a success."
Republican primary debate, Simi Valley, California; September 16, 2015

"I get a lot of credit for comb-overs. But it's really not a comb-over. It's sort of a little forward and back. I've combed it the same way for years. Same thing, every time."
Rolling Stone; May 11, 2011

"Do I look like a president? How handsome am I? Right? How handsome?"
Rally in Pennsylvania; April 25, 2016

"I could stand in the middle of 5th Avenue and shoot somebody and I wouldn't lose voters."
Rally in Iowa; January 23, 2016

"Just thinking to myself now, we should just cancel the election and just give it to Trump, right?"
Rally in Ohio; October 27, 2016

"Fake news."
Twitter; multiple instances, including December 10, 2016

"Don't be so overly dramatic about it. . . .You're saying it's a falsehood. . . . Sean Spicer gave alternate facts to that."
—Kellyanne Conway
Meet the Press; January 22, 2017

"I've done more than any other president in the first 100 days."
Associated Press interview; April 23, 2017

"The concept of global warming was created by and for the Chinese in order to make the U.S. manufacturing non-competitive."
Twitter; November 6, 2012

"Women: you have to treat them like shit."
New York magazine; 1992

"I'm not Steve Bannon. I'm not trying to suck my own cock."
—Anthony Scaramucci
The New Yorker; July 27, 2017

"When you're a star, they let you do it. You can do anything. Grab them by the pussy. You can do anything."
Unedited transcript of tape; *Access Hollywood*; 2005

"You know, it really doesn't matter what the media write as long as you've got a young and beautiful piece of ass."
Esquire interview; 1991

"I think putting a wife to work is a very dangerous thing."
ABC News, "Primetime Live"; 1994

"If Hillary Clinton can't satisfy her husband, what makes her think she can satisfy America?"
Twitter; April 16, 2015

"Lock her up!"
—Rally crowds
Multiple instances, including December 10, 2016

"Look at that face! Can you imagine that, the face of the next president? Would anyone vote for that?"
Rolling Stone; September 9, 2015

"You could see there was blood coming out of her eyes, blood coming out of her whatever."
CNN interview; August 7, 2015

"It's very hard for them to attack me on looks because I am so good looking."
Meet the Press; August 7, 2015

"If you see somebody getting ready to throw a tomato, knock the crap out of 'em. Seriously, OK? Just knock the hell—I promise you, I will pay the legal fees. I promise. I promise."
Rally in Iowa; February 1, 2016

"I love the poorly educated."
Campaign event, Las Vegas, Nevada; February 24, 2016

"We will have so much winning if I get elected. You may get bored with winning, believe me."
Rally in Washington, D.C.; September 9, 2015

"Look at my African-American here!"
Rally in California; June 3, 2016

"An extremely credible source has called my office and told me that Barack Obama's birth certificate is a fraud."
Twitter; August 6, 2012

"Frederick Douglass is an example of somebody who's done an amazing job and is getting recognized more and more, I notice."
Breakfast in honor of Black History Month, Washington, D.C.; February 1, 2017

"I love Hispanics."
Twitter; May 5, 2016

"That could be a Mexican plane up there. They're getting ready to attack."
Rally in New Hampshire; June 30, 2016

"Mexico will pay for the wall."
Twitter; September 1, 2016

"I have to have Mexico pay for the wall. I have to. I have been talking about it for a two-year period."
Phone call with Mexican president Enrique Peña Nieto; January 27, 2017

"Let's all hate these people because maybe hate is what we need if we are going to get something done."
CNN interview with Larry King; 1989

" . . . part of the problem and part of the reason it takes so long is nobody wants to hurt each other anymore."
Rally in Missouri; March 11, 2016

"I would bring back waterboarding. And I'd bring back a hell of a lot worse than waterboarding."
Republican primary debate, New Hampshire; February 6, 2016

"Don't tell me it doesn't work—torture works."
Campaign event, South Carolina; February 17, 2016

"He is not a war hero. He's a war hero because he was captured. I like people who weren't captured."
Family Leadership Summit, Ames, Iowa; July 17, 2015

"I really just see the bigness of it all."
Transcript of Associated Press interview, April 28, 2017

"I alone can fix it."
Republican National Convention; July 21, 2016

"We will have no choice but to totally destroy North Korea."
Speech at the United Nations; September 19, 2017

"On many sides."
Bedminster, New Jersey; August 12, 2017; also Trump Tower, New York; August 15, 2017

This book is dedicated with great affection to MGWS.

Library of Congress Cataloging-in-Publication Data is available.

ISBN 978-1-4521-7302-3

Manufactured in China

MIX
Paper from
responsible sources
FSC™ C008047

Design by Brooke Johnson

This book is a facsimile edition (with changes, additions, and deletions) of a one-of-a-kind hand-painted book created in the summer of 2017 by Ward Schumaker. The original is 56 pages, has a trim size of 19 by 12 inches, and is painted with acrylics and paste on Stonehenge paper.

10 9 8 7 6 5 4 3 2 1

Chronicle Books LLC
680 Second Street
San Francisco, California 94107
www.chroniclebooks.com

Chronicle books and gifts are available at special quantity discounts to corporations, professional associations, literacy programs, and other organizations. For details and discount information, please contact our corporate/premiums department at corporatesales@chroniclebooks.com or at 1-800-759-0190.

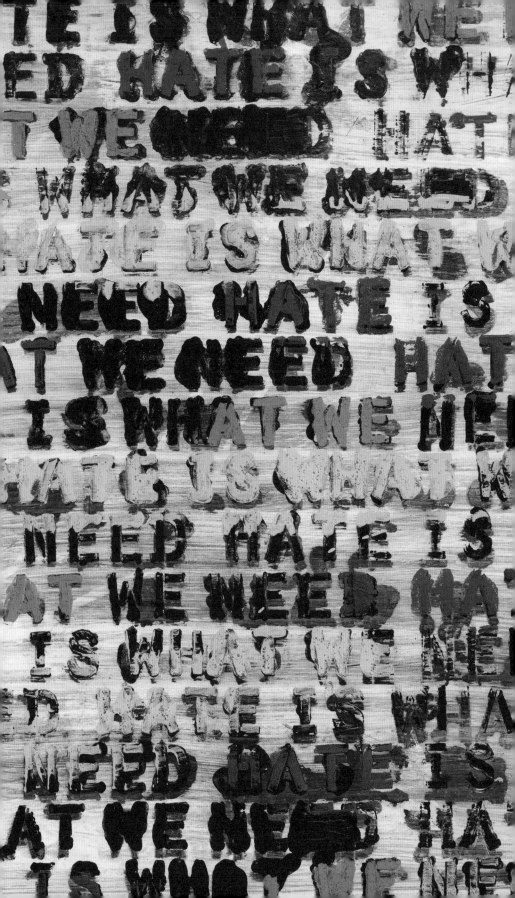